FAIRIES
to paint or color

DARCY MAY

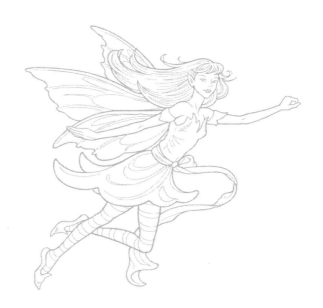

DOVER PUBLICATIONS, INC.
MINEOLA, NEW YORK

Note

Join the enchanted world of fairies with this delightful collection of charming vignettes. Delicate garden sprites cavort in their natural habitats, peering out from lush leaves and blossoms, frolicking with butterflies and birds, and even competing in a fun sea horse race! These lovely fairies are shown in the midst of their magical world in a variety of beautiful poses. One winged figure pensively gazes at her reflection in the water while another tiny fairy gracefully glides across a pond while holding onto the tail of a dragonfly. Simply add your own color to these exquisite illustrations to bring the natural vitality of these images to life.

Rendered by artist Darcy May, the 23 plates in this book are perforated for easy removal and are printed on one side only. In addition, the outlines have been printed in a light gray line so that they virtually disappear when colored in, resulting in a more polished and professional appearance.

Bibliographical Note

Fairies to Paint or Color is a new work, first published by
Dover Publications, Inc., in 2008.

International Standard Book Number

ISBN-13: 978-0-486-46544-9
ISBN-10: 0-486-46544-6

Manufactured in the United States by RR Donnelley
46544607 2015
www.doverpublications.com

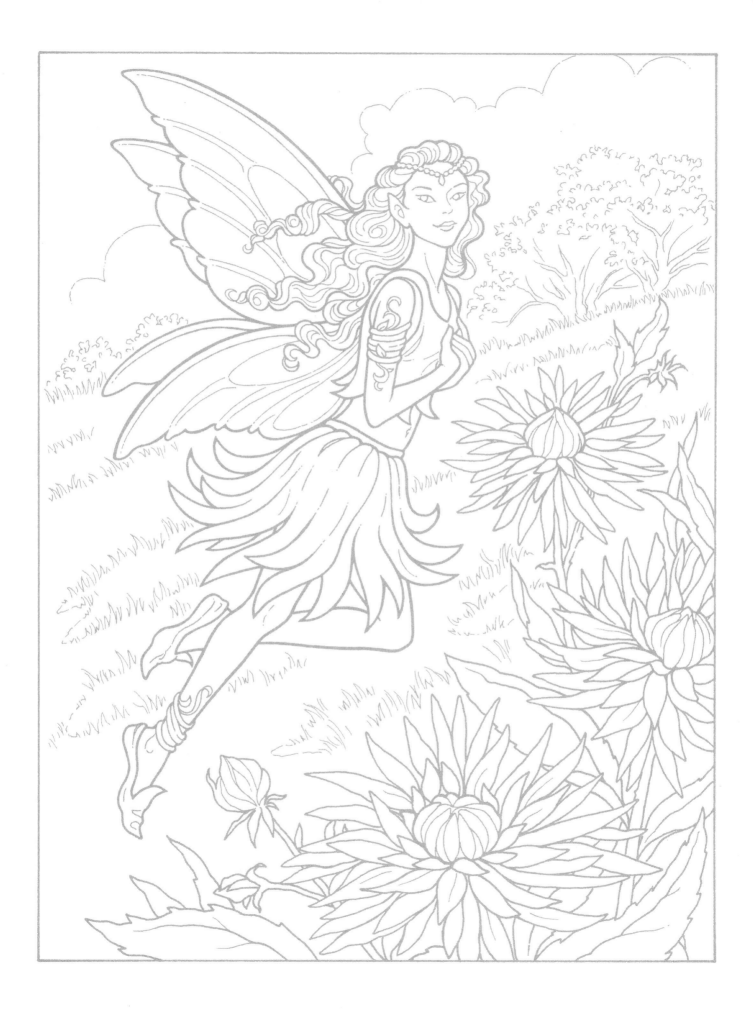

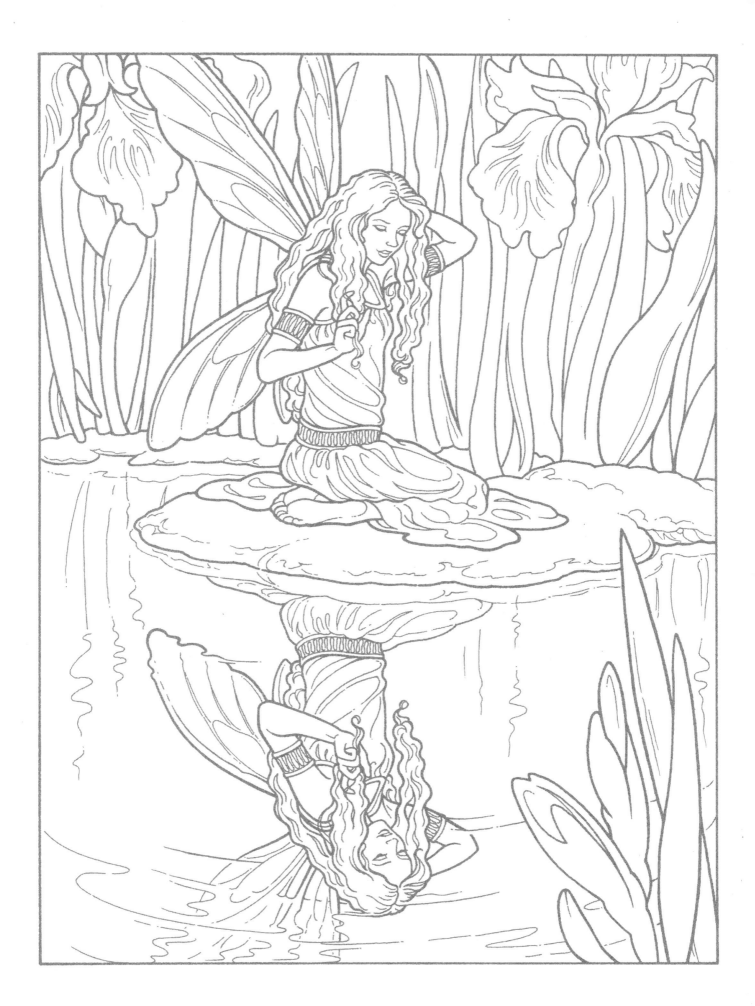

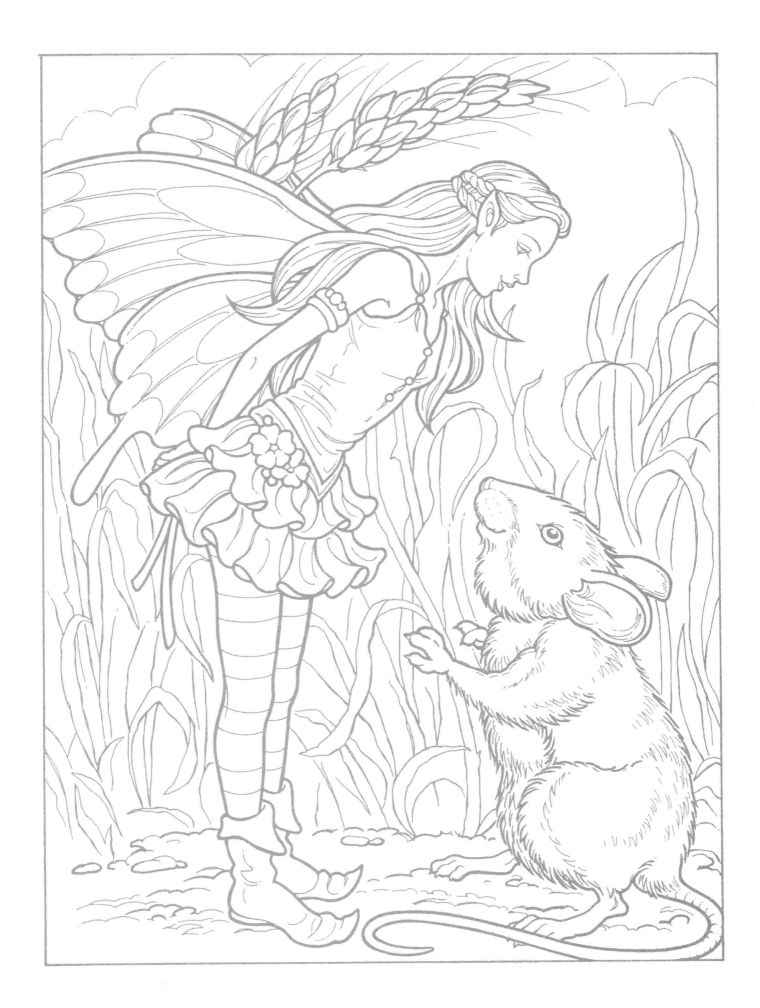

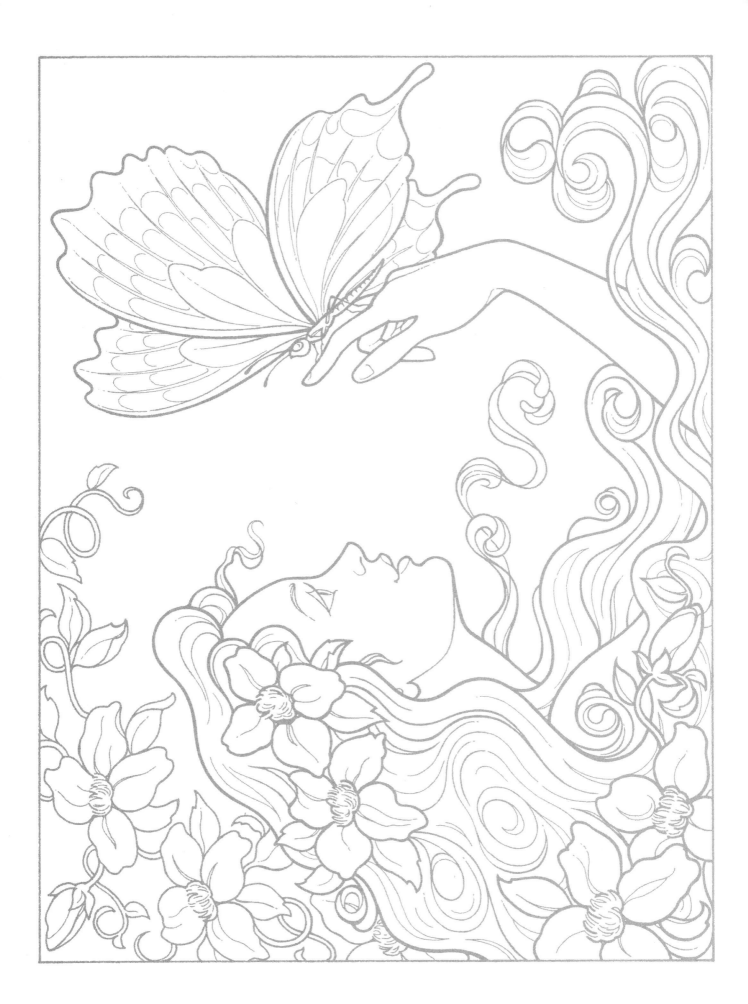

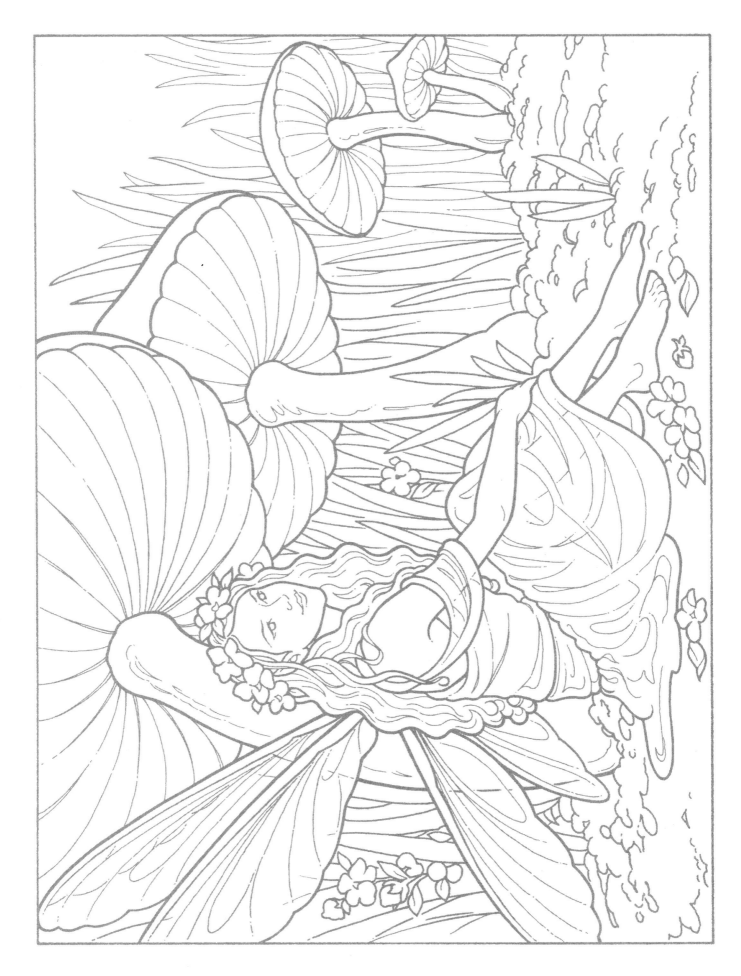

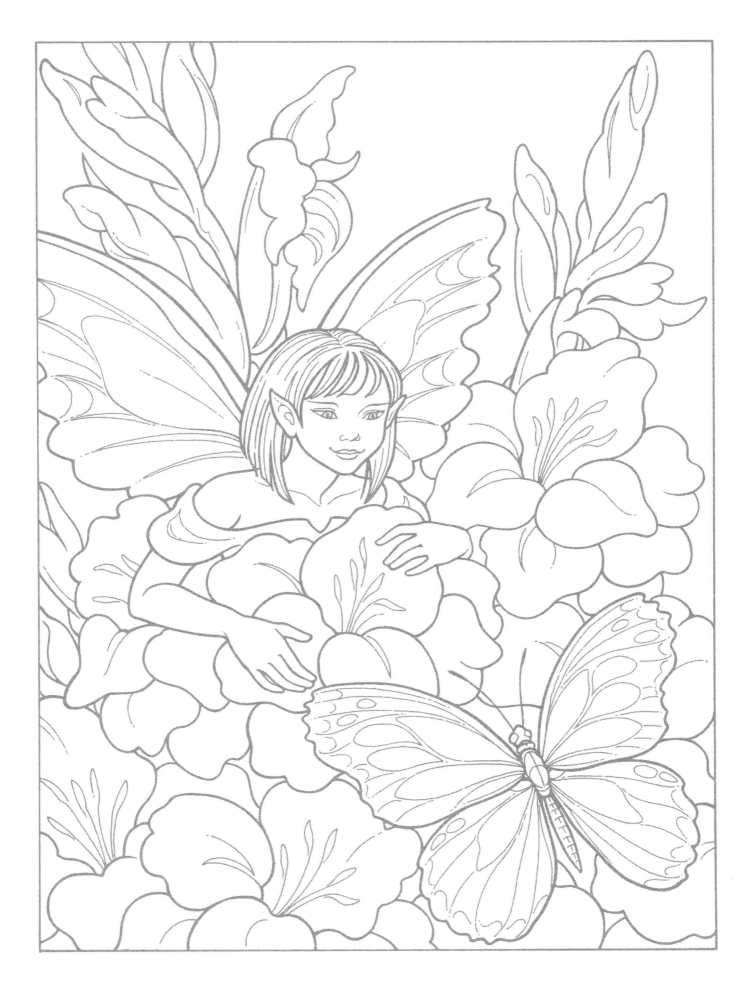

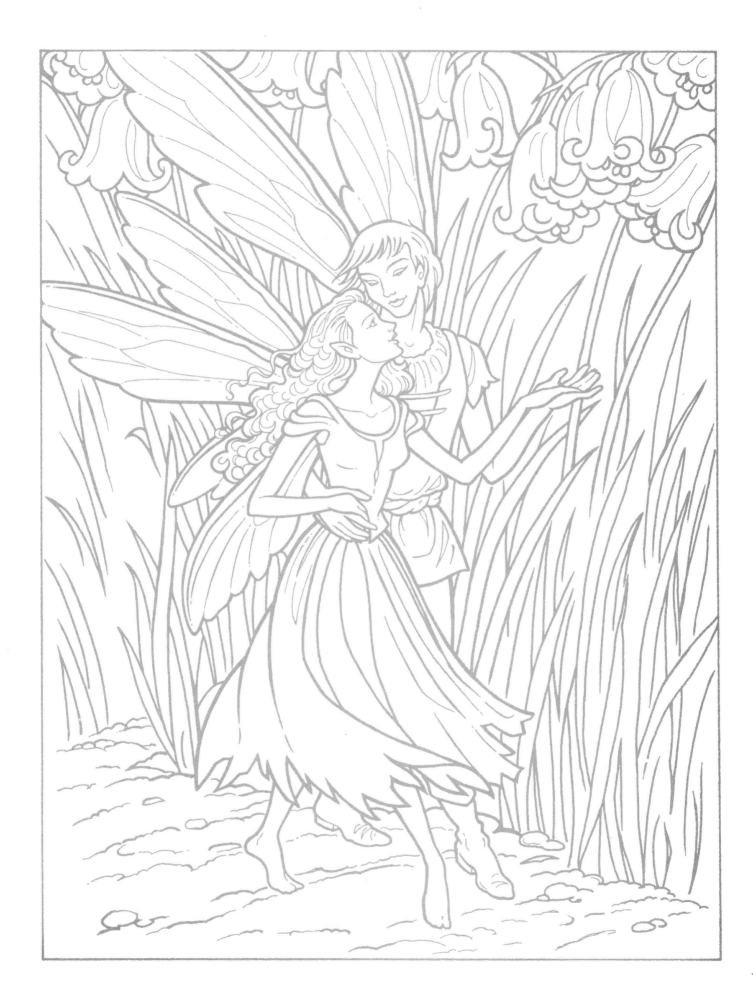

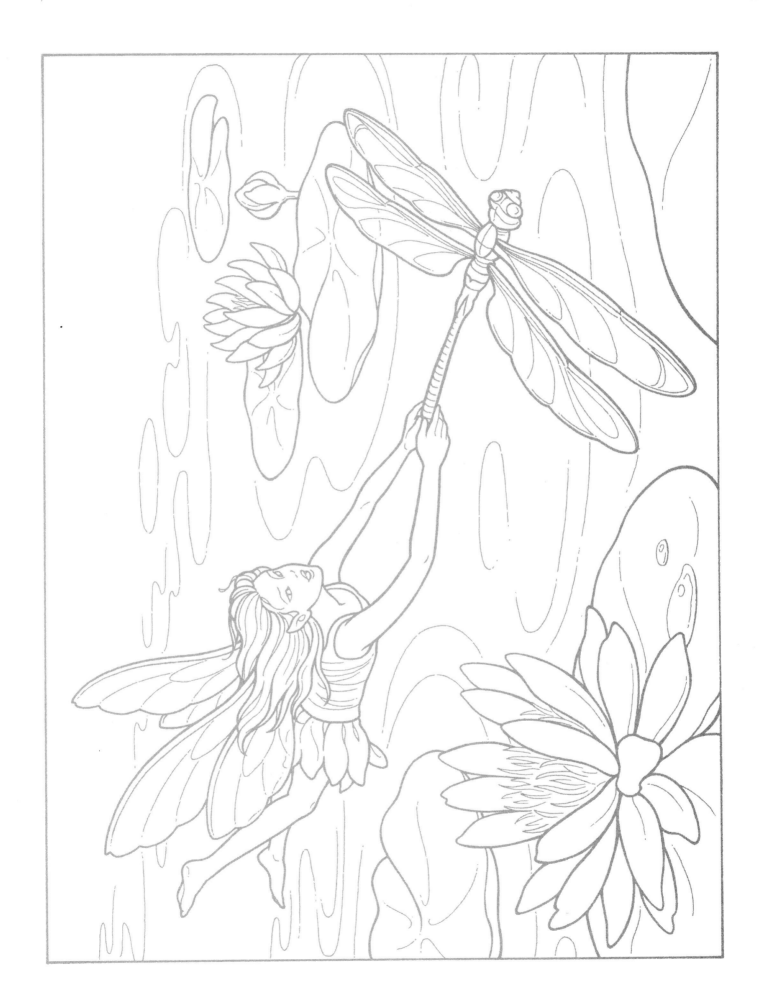

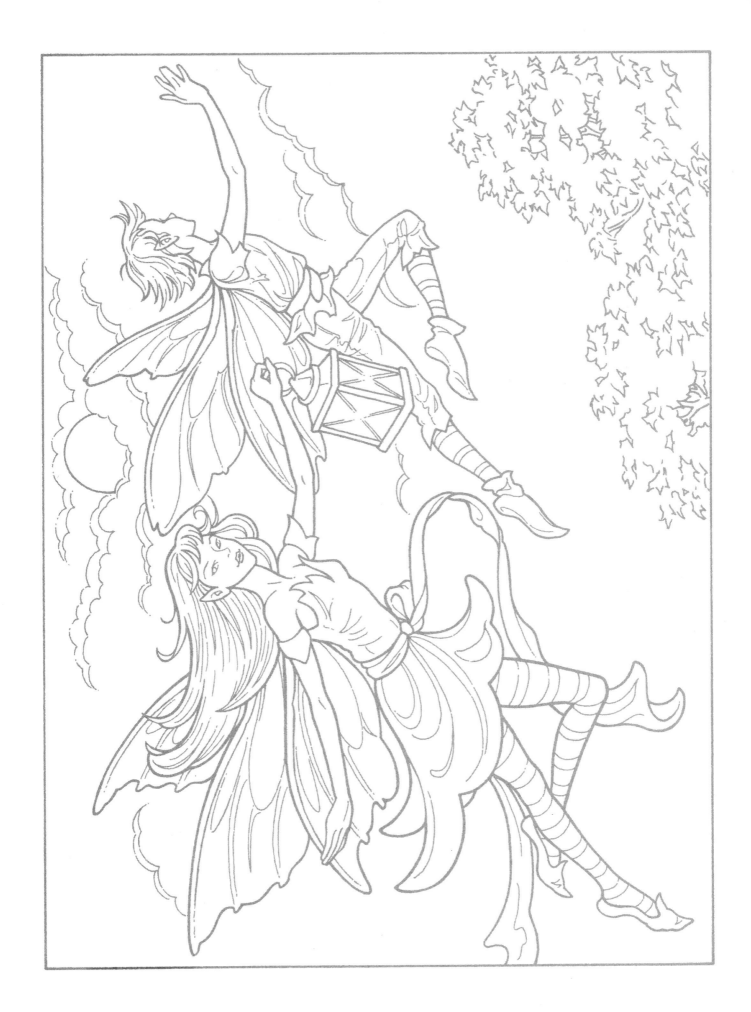

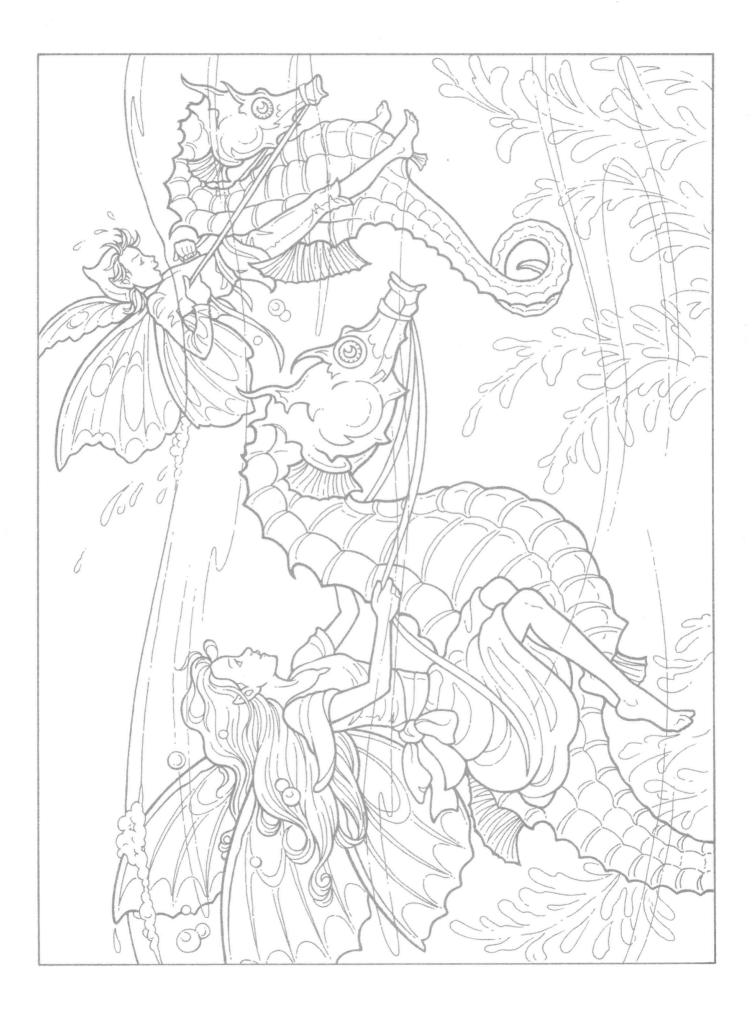

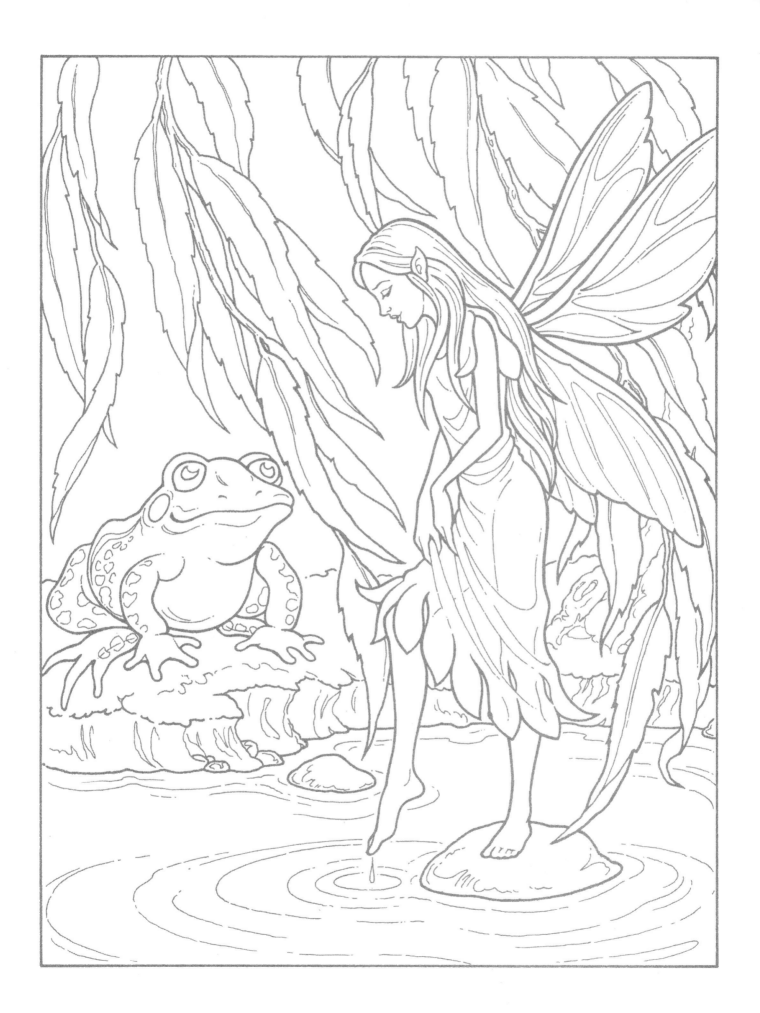

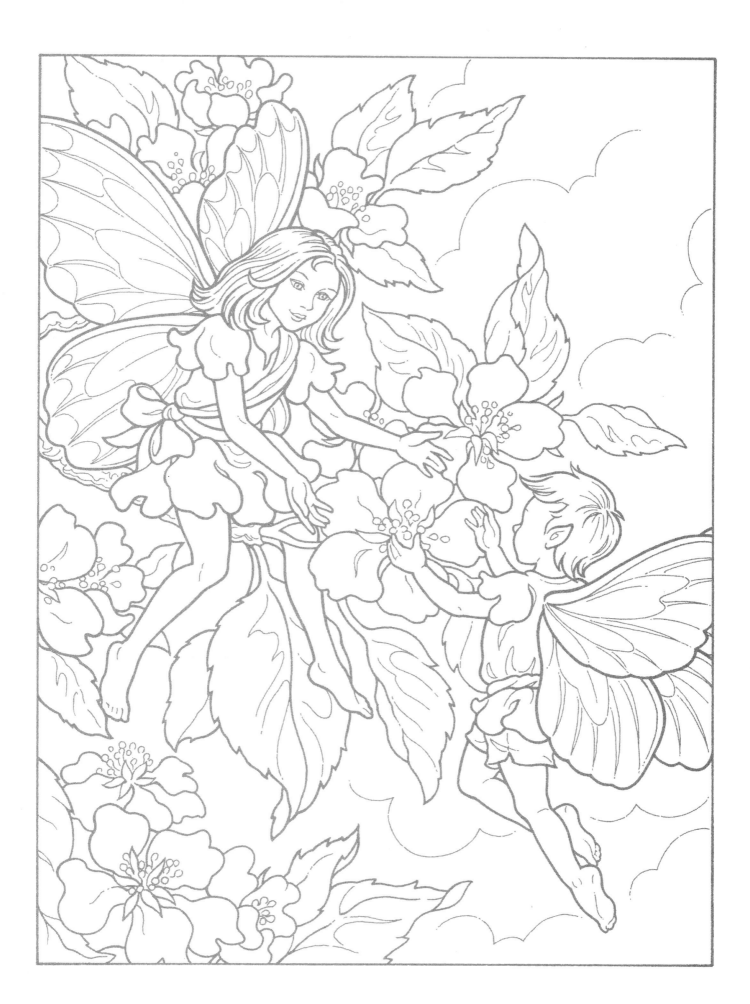

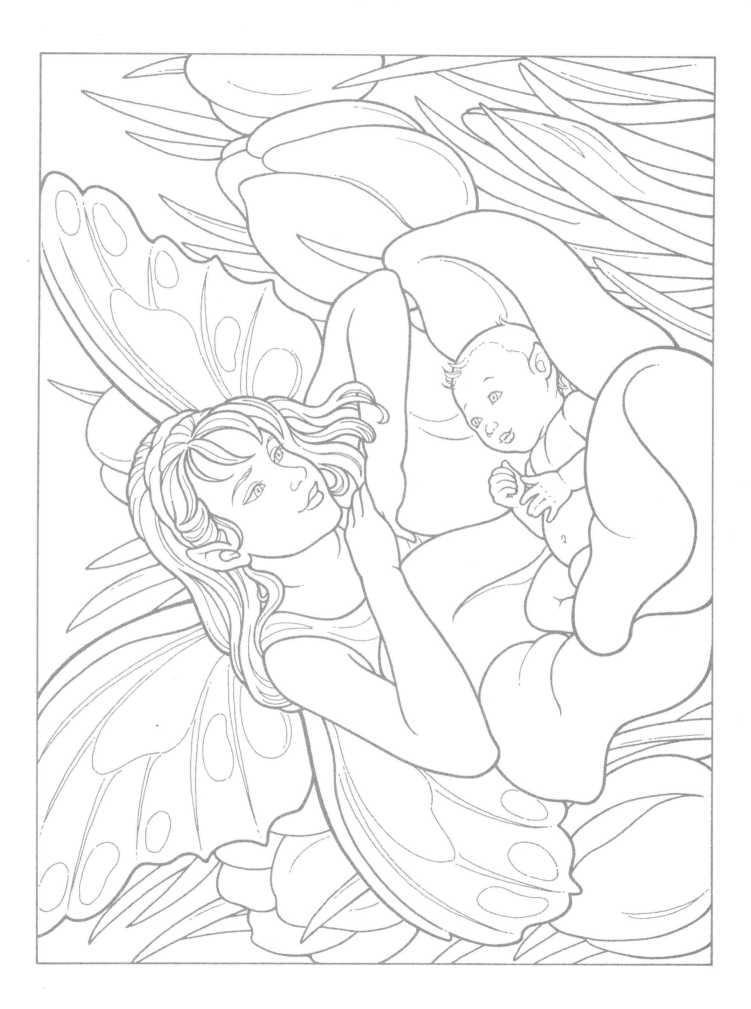

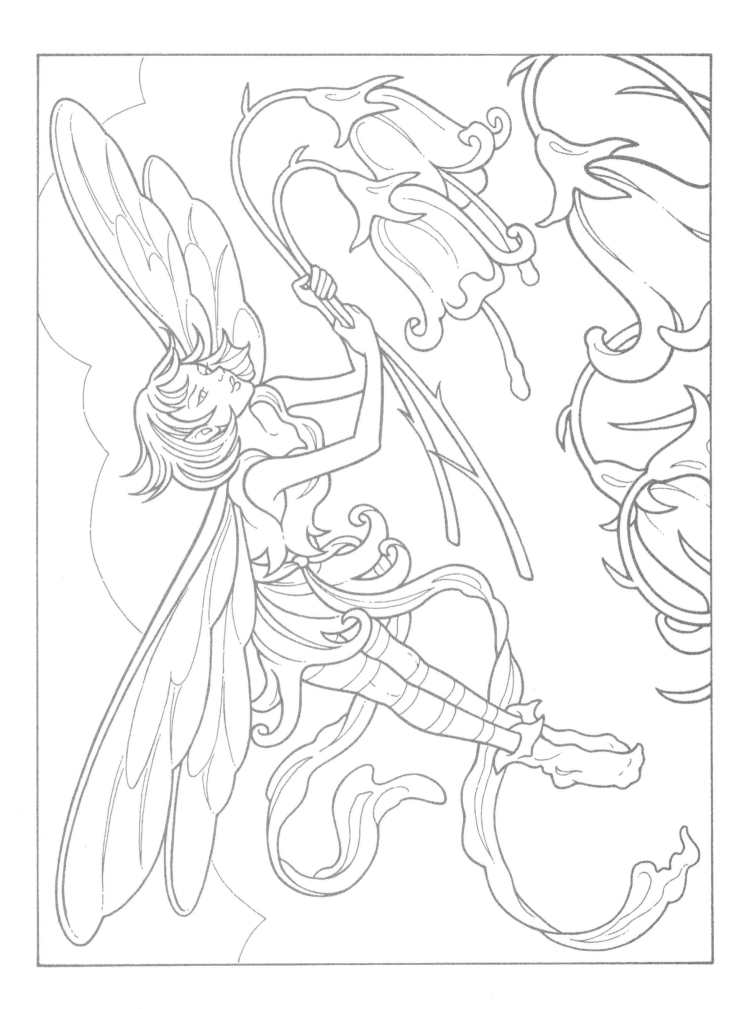

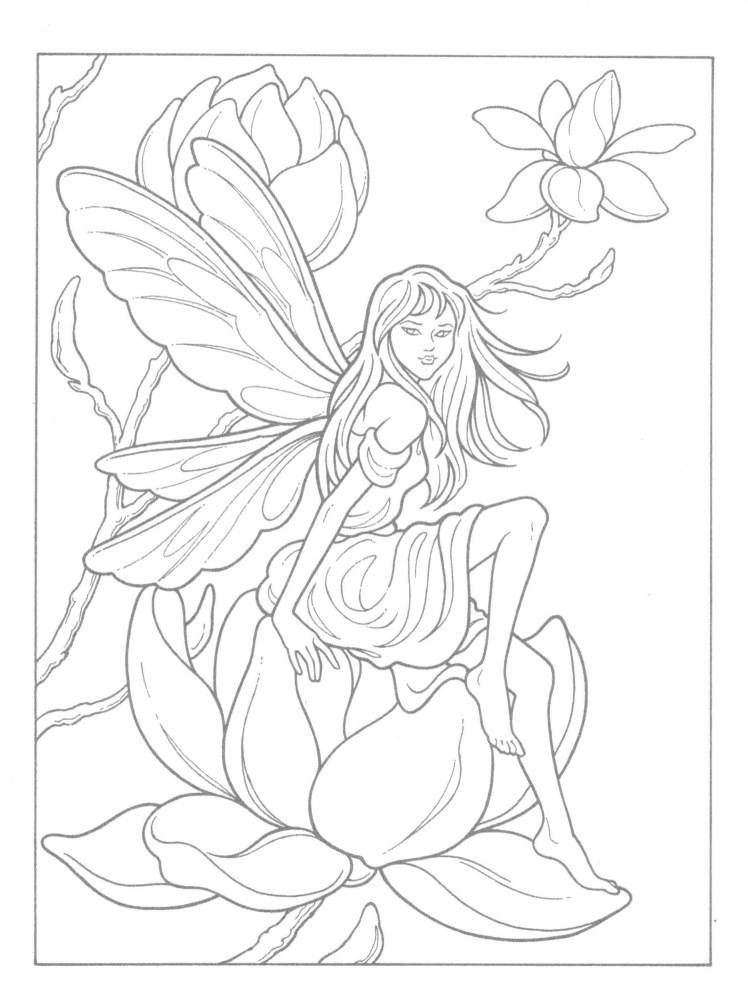

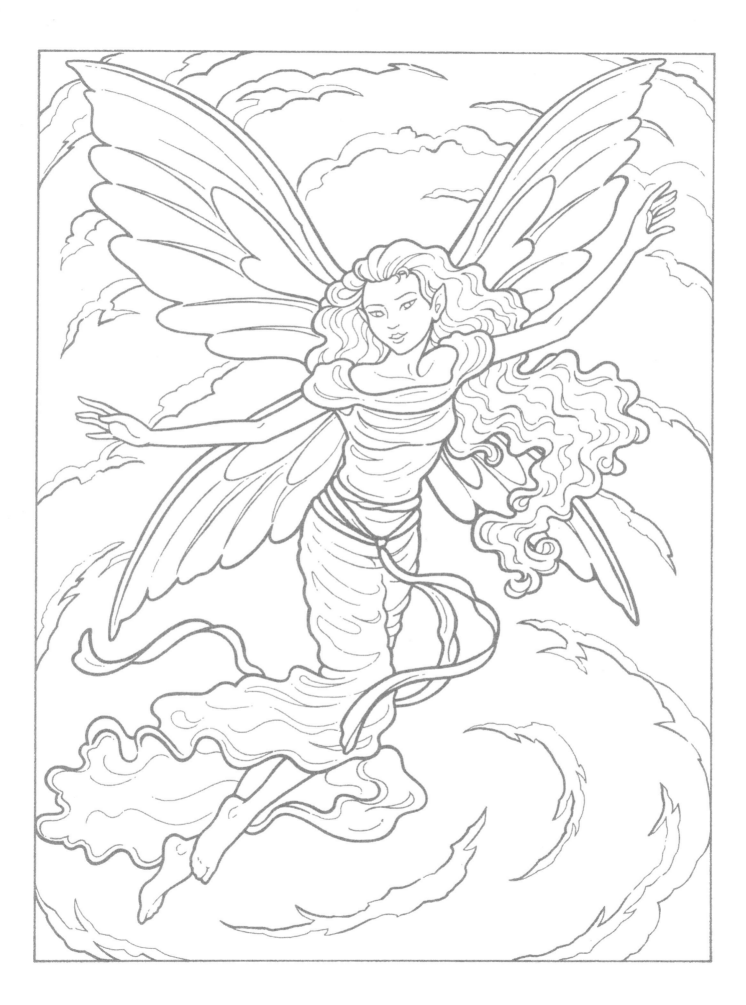

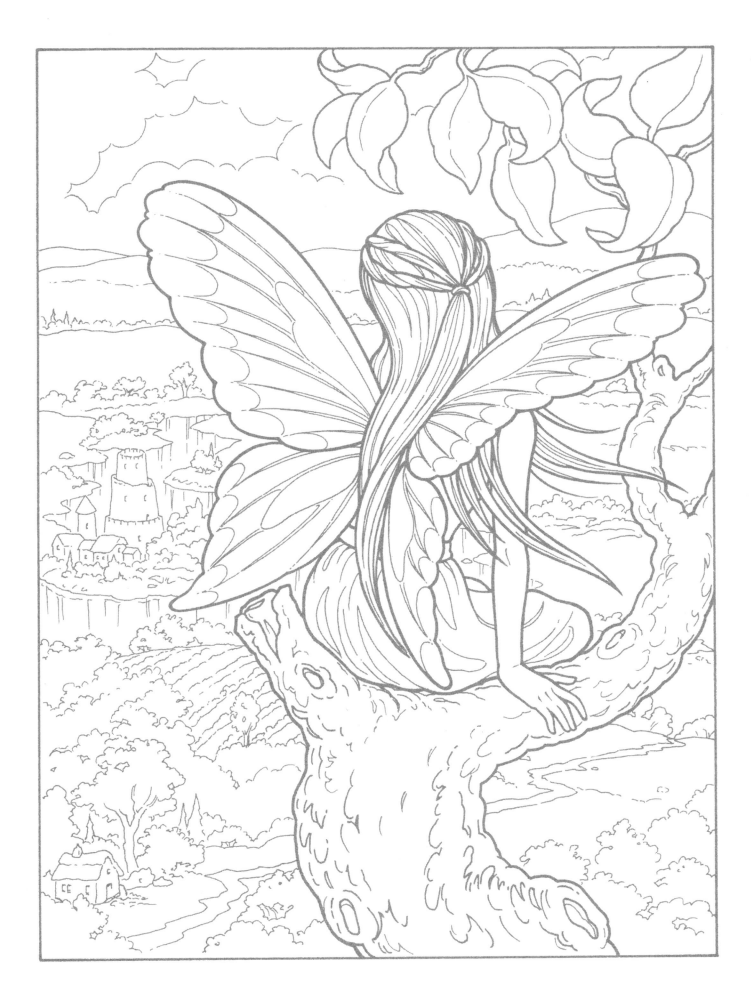

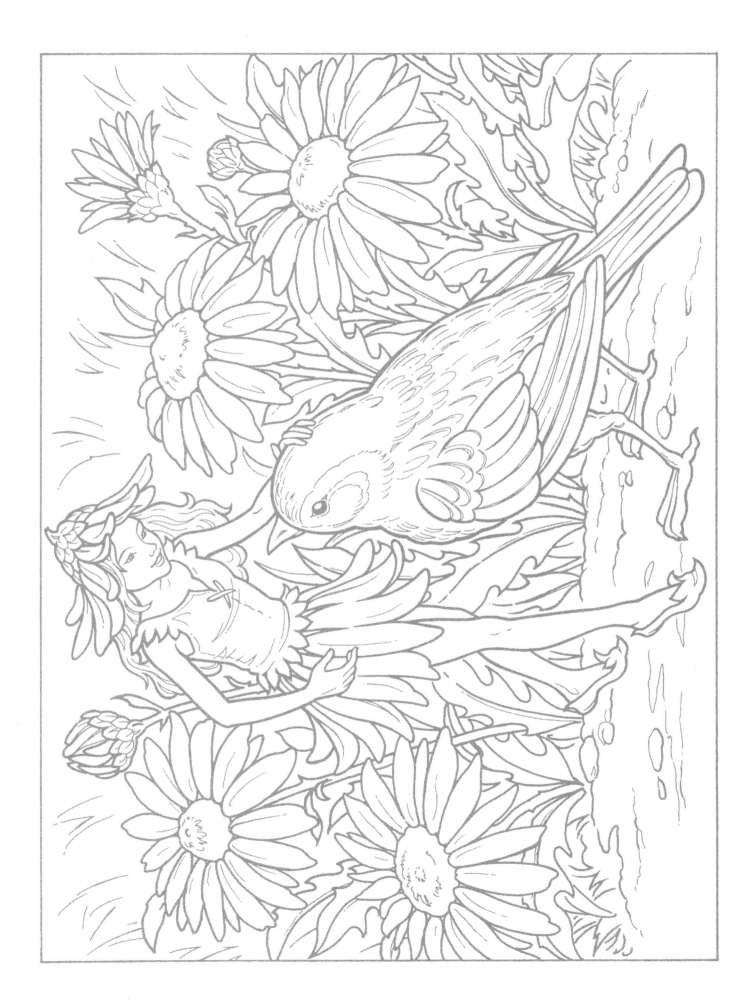

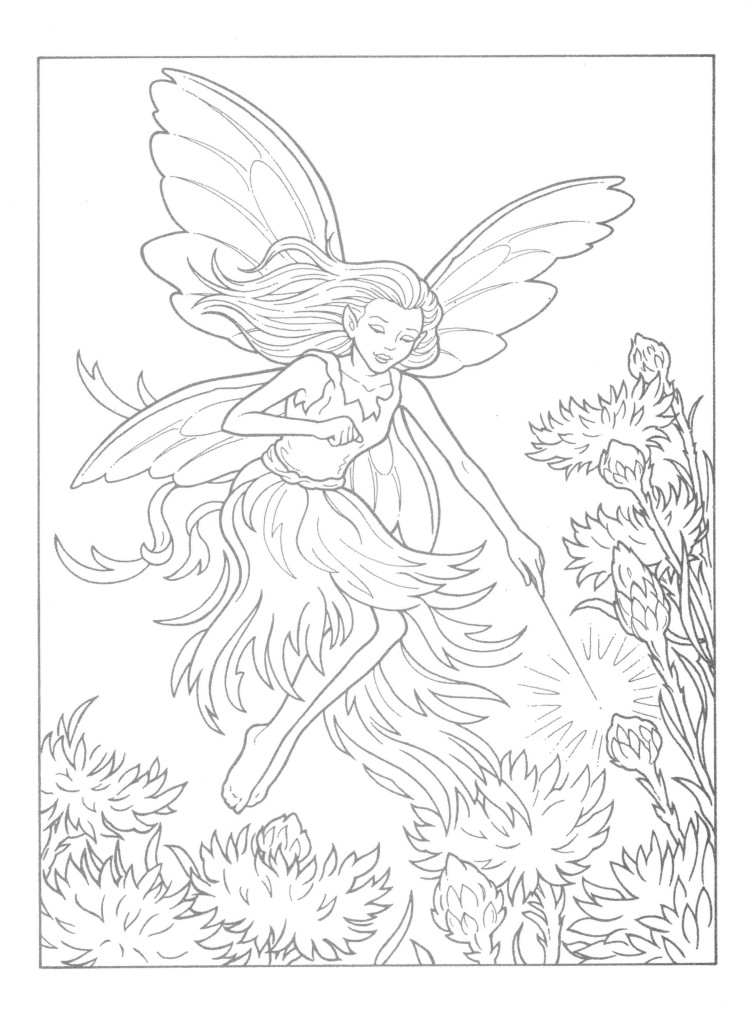

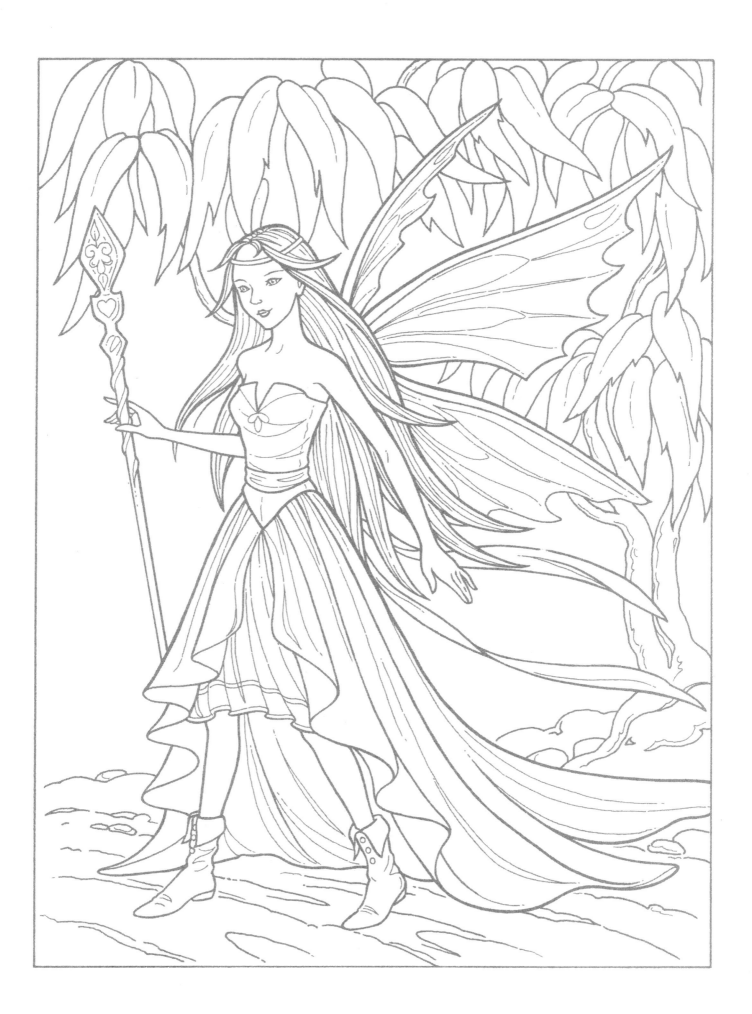

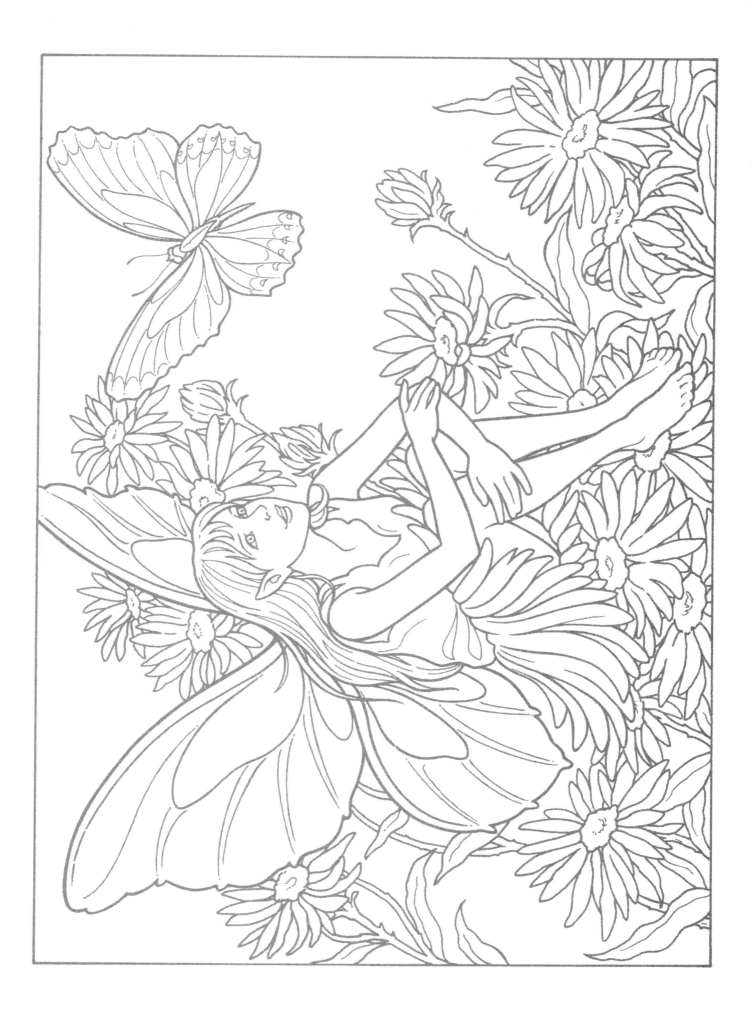

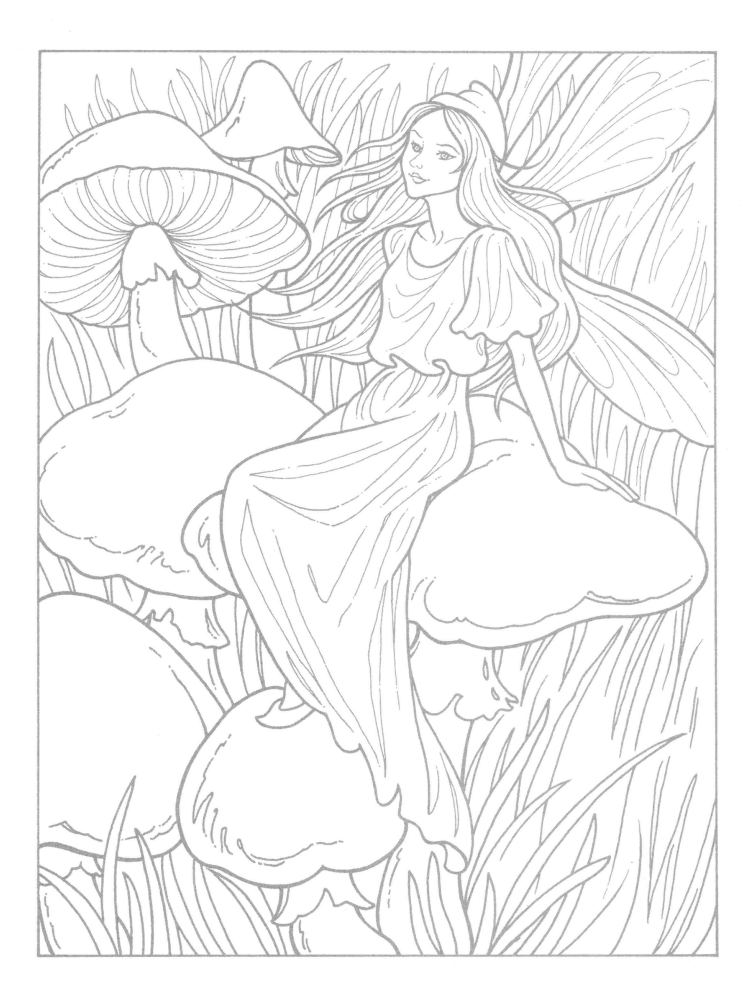